*This book belongs to*

...........................................................

_____

...........................................................

For my mum and papà, who
inspire me with positivity;
and Michael, my sweetheart
and note writer.

A MODERN
CALLIGRAPHY SKETCHBOOK

# NIB + INK

CHIARA PERANO

Cover Design, ABRAMS edition: Hana Anouk Nakamura
Interior Design: Ben Gardiner

ISBN: 978-1-4197-2434-3

First published in 2016 by Virgin Books, an imprint of Ebury. Ebury is part of the Penguin Random House
group of companies.

Printed and bound in China
10  9  8  7  6  5  4  3  2

Abrams Noterie products are available at special discounts when purchased in quantity for premiums and
promotions as well as fundraising or educational use. Special editions can also be created to specification.
For details, contact specialsales@abramsbooks.com or the address below.

ABRAMS
The Art of Books

115 West 18th Street
New York, NY 10011
www.abramsbooks.com

# CONTENTS

# getting started

## HOW TO USE THIS BOOK, ESSENTIAL TOOLS
### +
## PUTTING PEN TO PAPER

# A PERSONAL NOTE

Being a nineties' child, I had a favorite fountain pen and a huge box filled with different-colored ink cartridges. I wrote lengthy diary entries, made pen pals in faraway places, and partook in silly chain letters. Fast-forward twenty years and most of us don't write by hand much anymore. We email invitations. We send a thank-you text. We tweet a birthday message. Homework is submitted through websites. And why not? It's quick, convenient, and easy, and in our fast-paced, technology-obsessed society there's no denying that this is *just how* we communicate, and it will only continue to evolve and play a larger part in our lives in the modern world.

I *love* my digital products and am very thankful for how they aid us on so many levels, but I think it's good to have balance, and not let modern technology take over our lives. As humans we get real enjoyment from the results of "making," and there is a correlation between using our hands and keeping our minds active, alert and at peace. I promise

that the majority of people who attend my calligraphy workshops are amazed at how calming and artistic it feels to practice letterforms with a beautiful pen, and there's definitely something quite romantic about dipping a sharp nib into a pot of ink.

Perhaps it's been a long time since you put pen to paper? Or perhaps you have dabbled in handmade craft and want to take it further? Maybe you're getting married and want to wow your guests, or you just want to have the best-looking gift tags under the Christmas tree this year? Whatever your reason for wanting to get a pen back in your hand again, this book will help you reignite your connection with writing, to develop a modern calligraphy style you love, and, with practice, send out some damn fine stationery.

As a professional calligrapher, I get the opportunity to work on some amazing projects—from huge celebrity parties to fancy fashion events and super-luxurious weddings—

*write from*

and I feel extremely fortunate to be able to create calligraphy and lettering as my day job. But it wasn't always this way. For many years after graduating from the University of the Arts London I was a freelance illustrator and designer, barista and moonlighting mural painter, and it was only when I started Lamplighter London—my bespoke design and lettering studio—that I decided I would learn calligraphy to offer the service to my clients.

I have always loved type and handwriting, and have been happiest most of my life with a pen in hand, wooed by the romance and the love of illustration. With no convincing necessary, I bought as many nibs and penholders as I could get hold of, and started practicing, day and night. I learned the hard way—with lots of trial and error and mostly with the wrong tools.

I was not 100 percent confident in my calligraphy at first, and it took a while to really find my own style and believe in my work; it wasn't until I got a big commission from

HRH Princess of Greece and Nike in the same month that I had a lightbulb moment and realized I was probably on the right track! These days calligraphy dominates the studio. Lamplighter London has grown and focuses more on the beauty of calligraphy and spreading the love through handwritten elements.

Before we get started, an important point that I want to make is that modern calligraphy is simply a term that has come to describe the *new*, more immediate, and fun handwritten styles which have evolved from traditional types of calligraphy that date back to the fifteenth and sixteenth centuries, called Spencerian and Copperplate. Excitingly, these traditional styles use the same pointed pen as you will soon practice with, which is one of the things I love about it.

Calligraphy is a life-long passion for many, with talented masters taking their art seriously, constantly striving to perfect their script to

*the heart*

every millimeter of its form. The craft of the traditionalists will always be regarded as a meticulous skill, but the new art of modern calligraphy allows anyone to dabble, and enjoy the aesthetic and physical pleasures it brings.

I'm now spotting calligraphy and hand lettering more and more in everyday life. With the booming trend for personalization and lettering, handwritten stationery is having a moment in the spotlight, so it really is a great time to get involved. *Nib + Ink* will get your pen-starved hand back into action, delving straight into letter shapes, how to start with a modern calligraphy pen and, finally, exploring your own alphabet and working on fun lettering projects with loads of tips along the way.

Through my own education, teaching and modern calligraphy workshops, and from the daily emails I receive asking for advice, I have a good understanding of what beginners struggle with when they first pick up a pen. In *Nib + Ink* I've addressed some of the most common issues you might face (and what I wish someone could have told me when I first started out!). Have a look at the FAQs on page 168. Getting the basics right from the start will enable you to enjoy writing and encourage you to practice away to your heart's content.

Thanks for joining me.

*Chiara*
x

PERFECTION
*STIFLES*
CREATIVITY

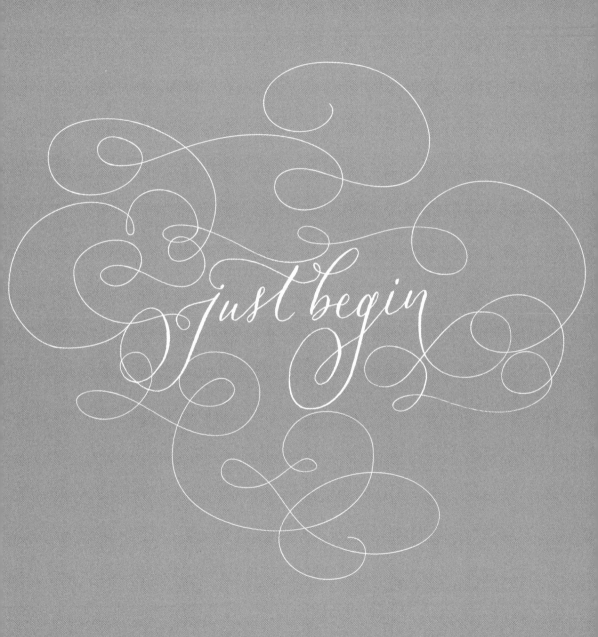

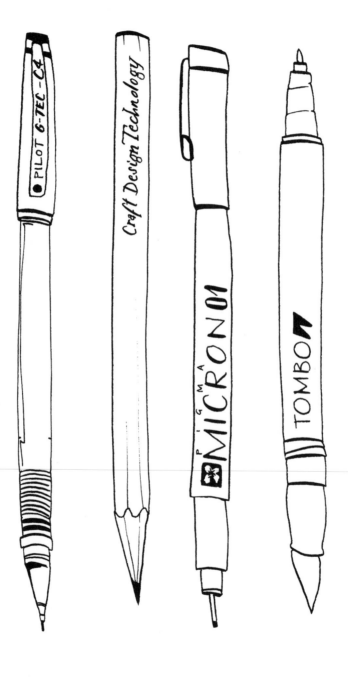

# HOW TO USE THIS BOOK

This book is for those who want to bring a handwritten element into their life. It's a beginner's guide to modern calligraphy and an exploration of the alphabet shapes. *Nib + Ink* is packed full of ideas, ready to help you write something with a script that is beautiful and fun. You can work through this book as a personal journal and begin with a regular pen or pencil, or you can indulge in buying the essential tools and inks you'll need to practice calligraphy from the beginning. If you prefer you can use a separate layout pad and guidelines sheet to practice in (see page 174 for supplies) or you can write straight into this book, tracing and overlaying the exercises. It doesn't matter how you get going, just get started!

We will run through the basic exercises of mark making, shapes, and letters in Letters, a section, you should master before you move on to Words, where you will learn how to write words and make flourishes. Each letter has a dedicated page with lots of style ideas for you to experiment with over and over — I promise, practice makes perfect! With illustrated tips and tricks throughout, you'll have support and expert advice to get through any beginner's calligraphy predicaments, and you'll soon be well on your way to bringing all these creative projects to life.

In Words you'll find template lettering for seasonal celebrations, which you can refer to whenever you need inspiration for a special occasion, and then it's on to the exciting Projects section. Here you'll discover projects from how to address an envelope or write gift tags to writing on chalkboards and framing quotes — all of which will fill your life with glorious handwritten goods. Each project features templates and ideas for you to try on a craft afternoon, either for making handmade gifts or to master a personal project.

To get you started, I've recommended some of my favorite supplies and included an FAQs section in the back of the book to help you with any problems and decipher all the new calligraphy terms and tools you'll come across within these pages.

One of the main goals of *Nib + Ink* is to make handwriting enjoyable and to help you discover a craft that's fun to try, as well as easy to access. Hopefully calligraphy will become something you'll love to practice and keep working at until you are creating beautiful stationery with your own personal style.

# THE FOUR ESSENTIAL TOOLS

You can simply use a pen or a pencil to start learning the alphabet and practicing shapes, and in fact, this is a great way to begin, so you can get a feel of the letterforms themselves (the pen makes it a little more complicated!). A sharp HB is the best pencil for calligraphy, and you can use any type of pen, although I recommend finding a smooth pen you like writing with.

To practice modern calligraphy you will need a few more suplies, and everything you choose will affect the outcome of your work — so be prepared to try a few and to practice with them. Choosing what suits you will enable you to create a unique style.

So, let's start with the basics.

## NIBS

There are *lots* of nibs out there. My recommendations all work perfectly for elegant modern calligraphy, but to get started I would recommend buying a few and trying them out to see which work best for you. Forget italic flat nibs, we're going to be using pointed nibs, which enable a lovely thin hairline and a contrasting thicker line. More on how that works later.

*tip*

Try writing out the same word in different nibs to see which you prefer to write with. It will help you to choose your favorites and remind you which work best for different styles.

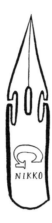

## NIKKO G
Modern Japanese nib, ideal to learn with, very smooth and durable, creates lovely thin hairlines.

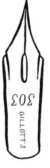

## GILLOT 303
Very sharp and very flexible, produces a thick contrast easily.

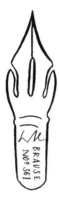

## BRAUSE 361
Easy to handle and can create bold lines without much effort.

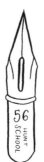

## HUNT 56
Sturdier, but still makes thin elegant hairlines.

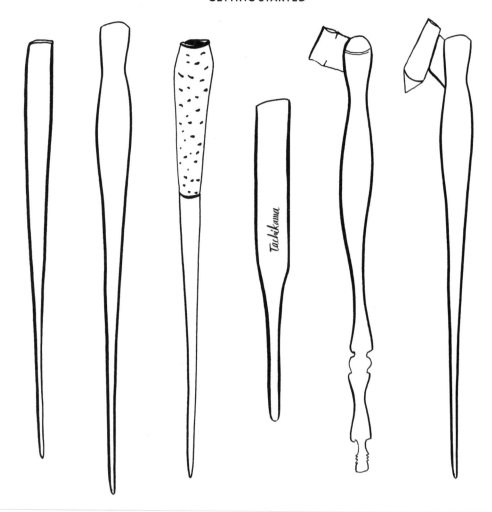

## PENHOLDER

The nib slots into a penholder, and again there are many options available within a choice of two main types. These two types are straight and oblique; straight can be used for left- and right-handers, whereas an oblique is mainly for right-handed calligraphers. I would recommend the straight to start with as it's more, well, straightforward.

Penholders vary in price from basic affordable plastic ones to super-fancy oak and mahogany turned bespoke beauties. The plastic ones are fine to learn with, and the wooden manuscript straight ones are great too, while the cork on some adds an extra comfort level. Slot your chosen nib into the prongs of the penholder — make sure it's in nice and sturdy. You don't want it falling into your inkpot.

## INK

Higgins Eternal ink is my first choice as it's smooth, long-lasting and doesn't clog up the nib. It's great to learn with as it glides easily, but it's not waterproof. I also love black Sumi ink because it's glossy and heavier.

If you like, you can experiment with making your own inks using a paint, gum arabic, and water mixture. To do this you'll need a mixing pot or jar, some distilled water, a pipette, and a clean paintbrush, and for the paint itself you can try using acrylic and gouache.

## PAPER

The type of paper you use will dramatically influence how your pen works. Some textured or thinner papers bleed, while others will snag, catch fibers and inhibit the flow of the pen. My favorite bleed-proof papers are:

LAYOUT PAPER
Thin, smooth, and its opacity works brilliantly for tracing through shapes.
Great for use with guides.

RHODIA DOT PADS
Good quality and smooth, with unobtrusive dots that work well as guidelines.

BRISTOL BOARD
Luxurious paper, thick, extra smooth, works well with paints and inks.

## EXTRAS

Have a little pot of water and a lint-free cloth on hand to wash off any ink build up . You can also invest in a lovely pot or tin to keep your nibs in — and don't forget some pen-cleaning fluid. I also use little wooden "pot blocks," which work as a pen and inkpot holder. These prevent little inkpots spilling and stop the pen rolling off the table, which can damage the nib. I originally made a couple of these to use myself but I find them so useful (and again, they were not easy to source in the UK while I was learning) that they're now available to buy from my website. All are finished by hand in East London.

*tip*

You can download a printable modern calligraphy guideline sheet for free at lamplighterlondon. com. Choose an 8½ x 11-inch or 5 x 8-inch PDF. This sheet will help keep your writing straight, letter size uniform, and help the angle to stay in check. If you place it underneath plain layout paper you can use it over and over again.

# PEN TO PAPER

Over the next few pages we're going to focus on getting you set up with your new tools. There is a bit of preparation involved here, and you'll probably need to adjust your "hand," which will be tricky at first as it is something you've grown accustomed to since a child. Don't worry, though, just remember to have fun — it's all about experimentation.

The most enchanting thing about modern or pointed pen calligraphy is that you're totally in control of the outcome — you will *apply* and *release* pressure on the pen with your index finger, which in turn changes the width of the stroke as you do so.

What?! You ask. Ok, take a closer look at how the nib is formed:

The tines are actually two sharp prongs that separate when pressure is applied — this is how we create strokes of different widths. At resting position the two together form a fine point, but as soon as the tip touches the page the ink will flow to make a very thin mark. When pressure is applied to the nib (on the downstroke) the tines will separate to form the wider line — kind of like a paintbrush stroke. As we release the pressure they spring back together, and the trick is to make that a gradual, controlled transition, which I will explain in the next chapter.

*tip*

**LEFTIE TIP:** If you're left-handed you'll fall into one of two types of writers: "under" (you hold the pen out in front of you), or "over" (you curl your wrist over the page). For underwriters you can simply mimic how righties work — the nib is symmetrical. For overwriters you'll need to work in the opposite way, because you'll be putting pressure onto the nib as you pull the pen upwards. Move and turn the paper as you see fit — some find it easier to work with the paper at 90 degrees to their body. Have a play around to see what works for you — either way, lefties can use a straight penholder with ease — so no excuses!

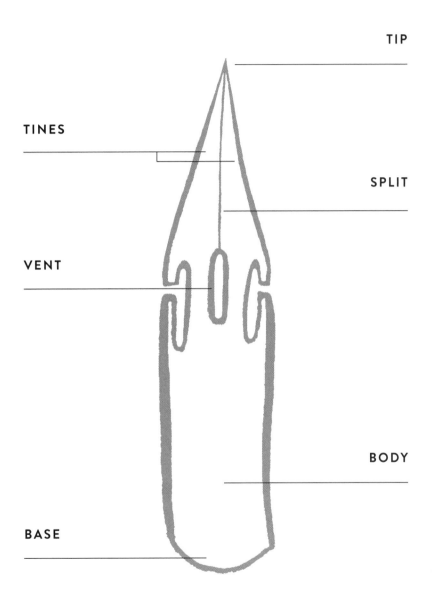

TIP

TINES

SPLIT

VENT

BODY

BASE

# HOW TO HOLD THE PEN

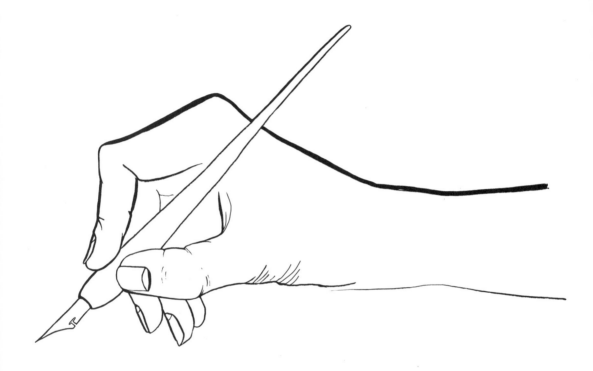

Hold your pen lightly — trust me, you'll end up with writer's cramp if you are squeezing that pen too tight! Calligraphy works best if you use fluid motions and have relaxed shoulders, arms, and fingers.

Sit up with your back straight and support your arm and wrist by placing them flat on the table — this will also help you control the pen and eliminate any shakes. Put both feet on the floor for balance.

Rest the side of your palm lightly on the table and ideally the pen should sit on your middle finger. Hold the lower end of the pen between your index finger and your thumb, about half an inch away from the end of the penholder to get the most control and to avoid getting inky fingers in seconds! Make sure the pen is not too upright — you want it to rest nicely in the nook of your hand.

The majority of the movement in calligraphy comes from the arm; avoid writing with your fingers and keep your wrist and hand as one unit, moving in smooth motions. Try to practice this without putting pen to paper, as it may be quite different to how you usually hold a pen.

You can turn the paper as necessary, adjust the angle that you're sitting at, or do what it takes to get comfortable. All that matters is that the pen and your arm are facing in the right direction. Some calligraphers use a slanted table, but I just use my normal desk and sometimes a lightbox. You can use what works best for you.

We're going to be dipping the nib into a pot of ink, and you will want to make sure the reservoir of the nib is filled enough so that you get a good stretch of letters without having to re-dip constantly. You can dab off any excess ink on the side of the jar.

Gradually you will know how often you need to re-dip for more ink, but at first you may need to go with the flow (literally!). You will probably experience the ink running out mid-letter a few times before you get it right.

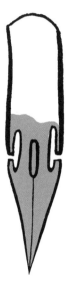

*tip*

Tuck a few sheets of paper under the one you're writing on to create a cushioned effect.

PART TWO

MARK MAKING,
THE MODERN
CALLIGRAPHY
ALPHABET
+
SYMBOLS

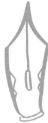

# MARK MAKING

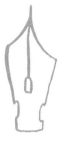

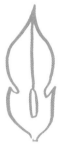

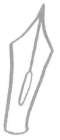

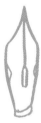

A lot of the letters in a calligraphy alphabet are formed of the same structural shapes, and it's important to get the hang of these individual letters and feel comfortable going in all the different directions with the nib before you start writing out full words.

So here we're going to start with the basic shapes and begin to make marks on the paper. Remember to take it slow, at least half as slow as you normally write. It's not a fast activity — you can't rush calligraphy; the pen just won't work if you do. If you start to feel tense in your shoulders and arm, loosen up your hand by doodling very lightly with the pen and stretching out your fingers as you do so. Drop your shoulders, too; it really helps to relax your arm — and please remember to breathe!

Start by dipping your nib into the ink as shown on page 25, then touch the tip to the paper and make thin, repetitive, short marks — slowly. When you've done a full page of lines that are all of a consistent width, start to make broader strokes; as you pull the pen toward you, add pressure to make the thicker lines.

If the lines are not coming out very thick, try applying a little more pressure onto the nib, which will cause the tines to separate and allow more ink to reach the paper, thus creating a heavier stroke. Copy the examples underneath — use layout paper here to trace the shapes for further practice.

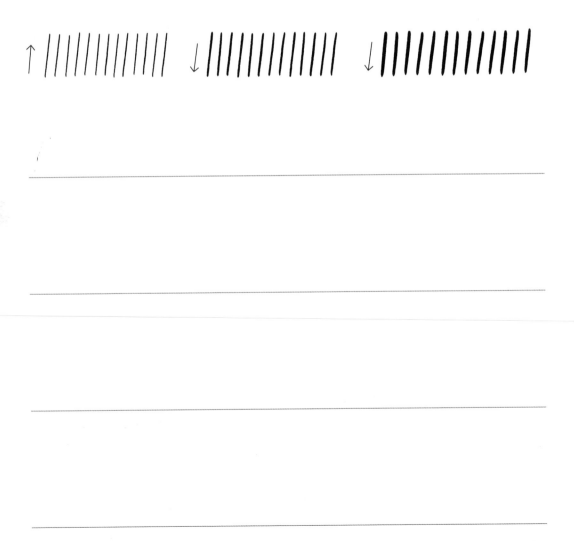

Now try putting the two strokes together. The
upstroke is always a faster, lighter movement,
so be as light as possible with your hand, almost
gliding it up the page. The downstroke — when
you pull the pen back toward you — is the
heavier stroke. You will need to go slowly to
control the different pressure.

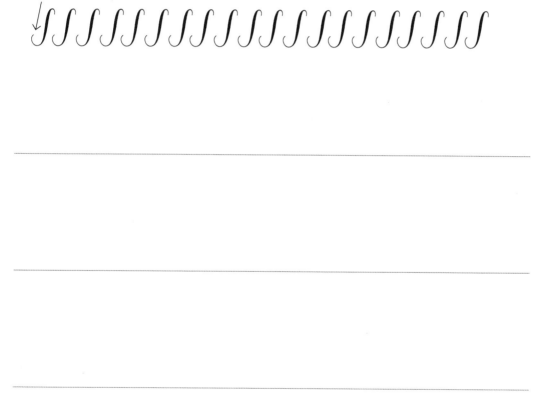

When you've got the knack of the flow of the two different strokes try the following exercises, putting into practice the hard-and-fast rule: always stay light on the upstroke and increase the pressure on the downstroke. There should be a rhythmic movement to your up- and downstrokes, which helps balance and calm your hand.

*tip*

Don't watch the nib! It's quite off-putting and disconcerting. Focus on the shapes you are making with it instead.

*tip*

Sometimes it's hard to figure out what's going wrong with calligraphy — if the nib is scratching or something's not quite right, check the FAQs list on page 170 for help and advice.

Aa Bb Cc Dd Ee

Ff Gg Hh Ii Jj Kk

Ll Mm Nn Oo Pp

Qq Rr Ss Tt Uu

Vv Ww Xx Yy Zz

# THE MODERN CALLIGRAPHY ALPHABET

We have to master letter formation before starting on words. It can be so tempting to rush through this section and start writing out words, but I promise it will be worth the wait if you nail the letters first. If you jump too far ahead you'll only have to come back to the alphabet later.

The proportion and set up of your letters is important, and over the next few pages we will be working on forming the shapes and paying attention to this. If a letter isn't looking right, it can often be that parts are too far apart or loops are too big and top heavy. Check for this in your practice.

Below you can see a sentence that I've written in which all the lowercase letters sit between the two smaller lines, and all letters start on the baseline. The ascenders and descenders of the letters are all at the correct height and this creates a uniform script. This is how to correctly use the guidelines over the next few worksheet pages.

If you're having trouble with a particular letter, practice it over and over again — building the muscle memory will really help and you'll be able to see your improvement after you've written it out ten or so times. Practice the letters in their many variations — formal, modern, loopy, angular — and see what works best for you. Repetition is the key to mastering the shapes. Trace, copy, explore! Just practice, practice, practice, enjoy the letter shape and relax.

*How the guidelines work*

**BASELINE**     **DESCENDERS**     **ASCENDERS**

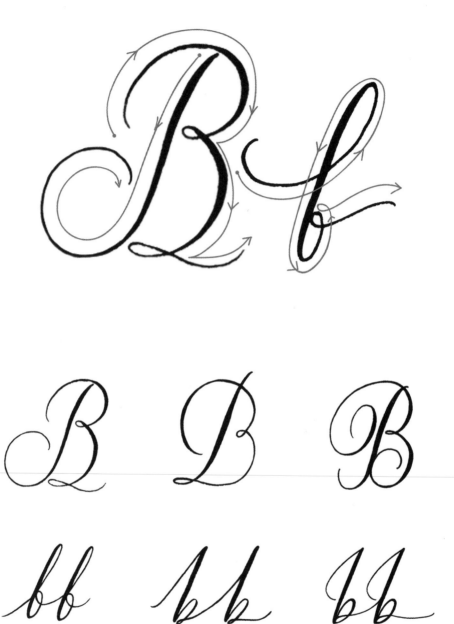

*Bb*

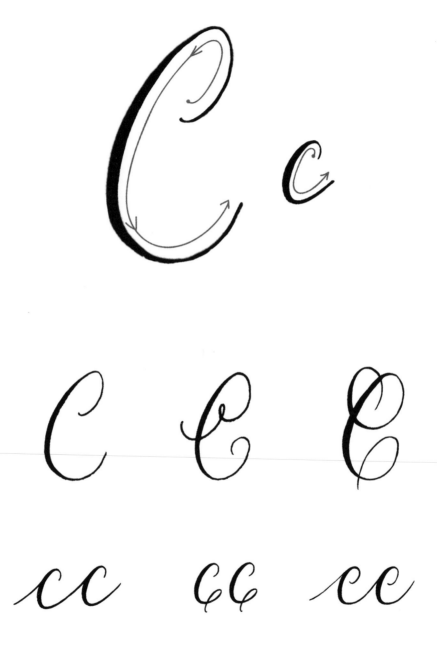

*C c*

D d

D D D

dd dd dd

*Dd*

*practice makes perfect ...*

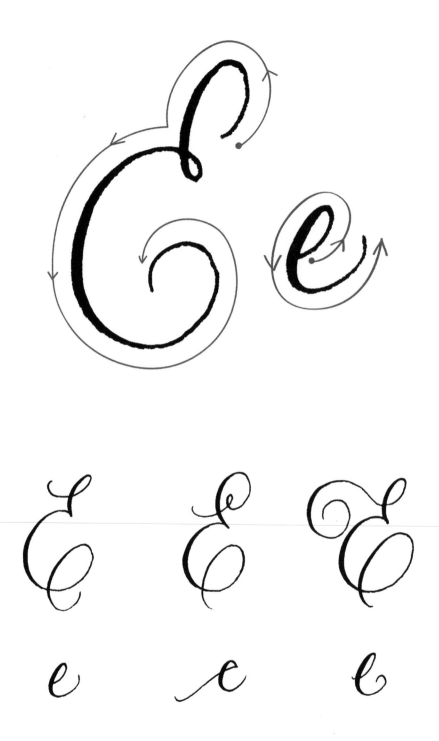

*E e*

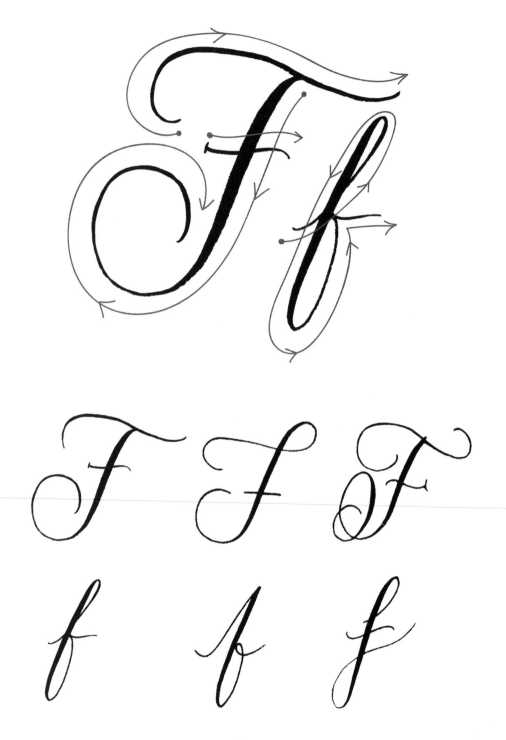

$\mathcal{F}f$

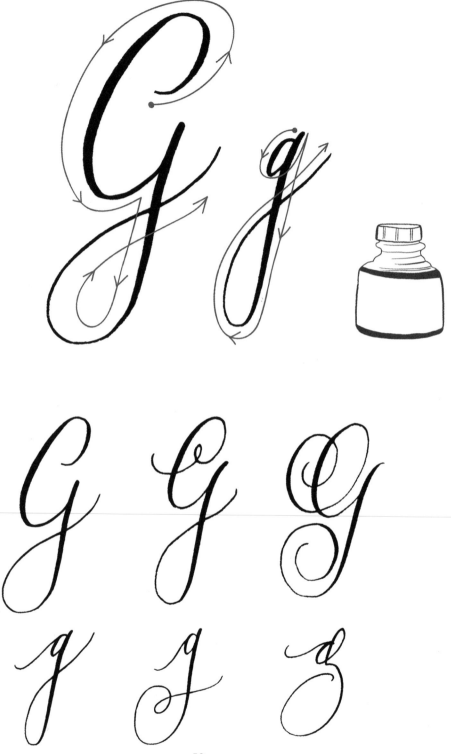

*G g*

$\mathcal{H}\,h$

*tip*

Remember to keep a nice slow pace with your practice. Enjoy making the letterforms!

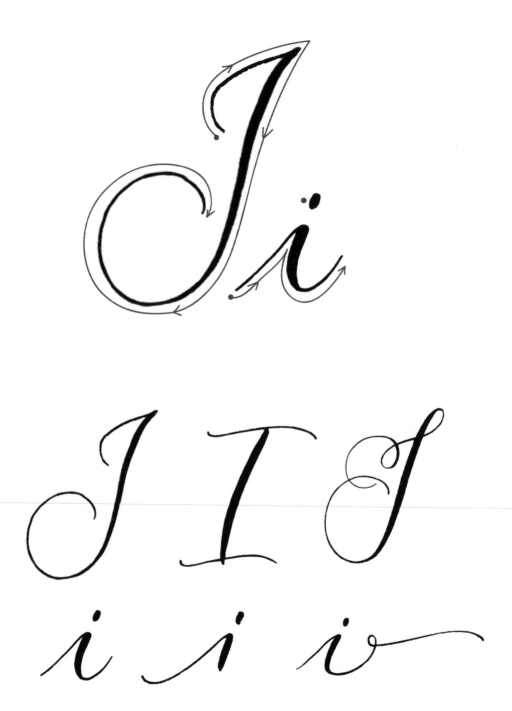

*Ji*

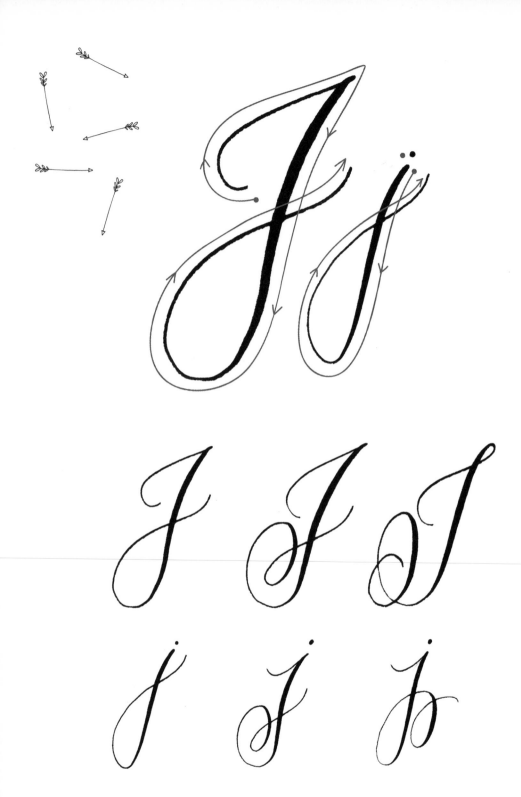

$\mathcal{J} \mathcal{J}$

*K k*

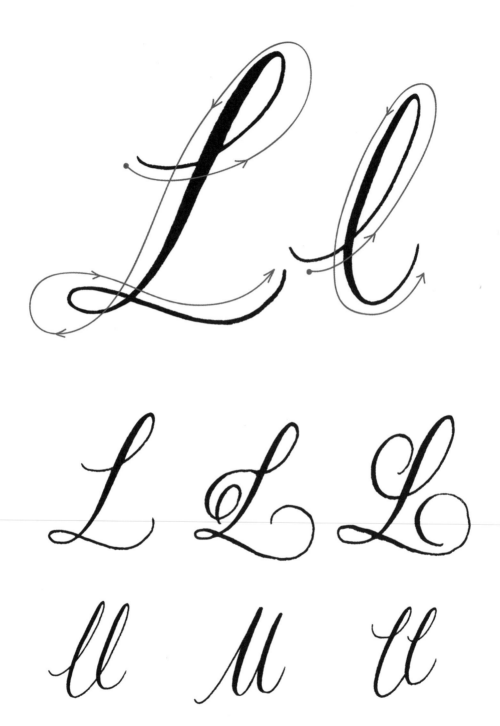

$\mathcal{L}\,l$

keep at it!

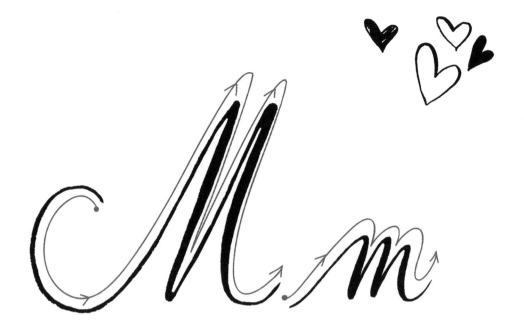

*M m*

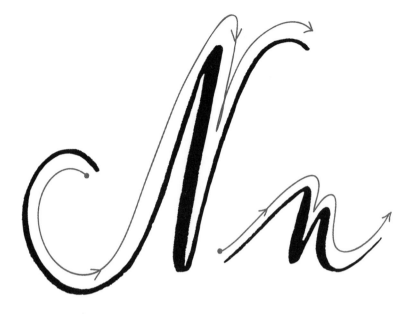

$\mathcal{N}\, n$

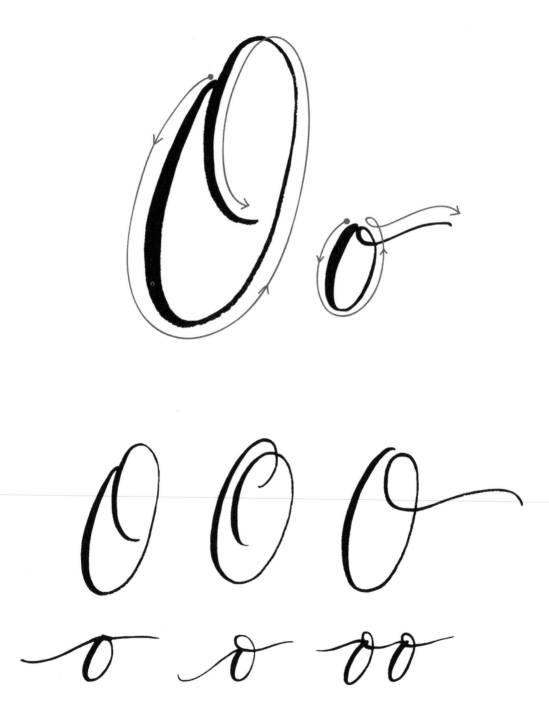

$\mathcal{O}\,\sigma$

$\mathcal{P}p$

*tip*

Practicing your letterforms will make for beautiful finishes and improve your calligraphy.

$\mathcal{Q}$ $q$

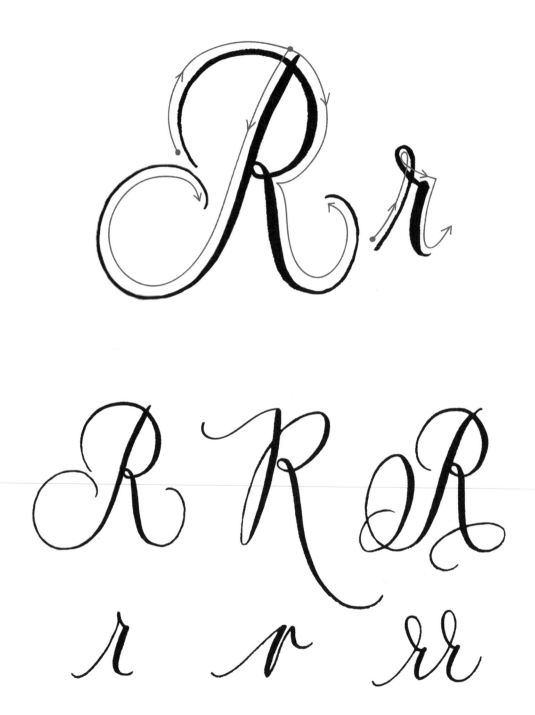

$\mathcal{R}\, \mathit{r}$

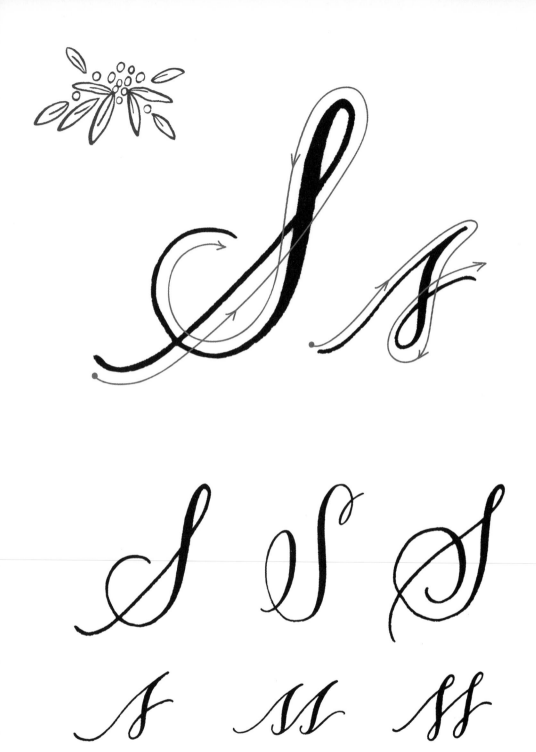

*S s*

$\mathcal{T}t$

enjoy

И Им

и И И

м м ми

Ии

$\mathcal{V}v$

*W w*

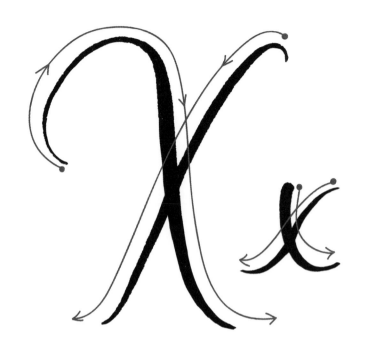

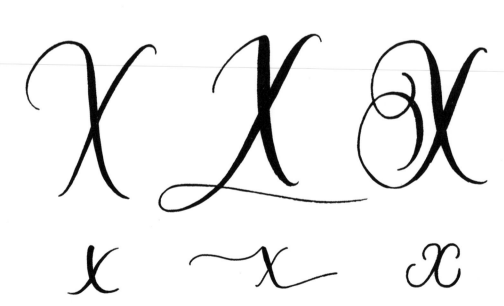

$\mathcal{X}x$

*tip*

Don't fall into the habit of doing your usual handwriting with a calligraphy pen — unless that's the look you're trying to achieve! Focus on each letter and go for creativity and flair.

_Yy_

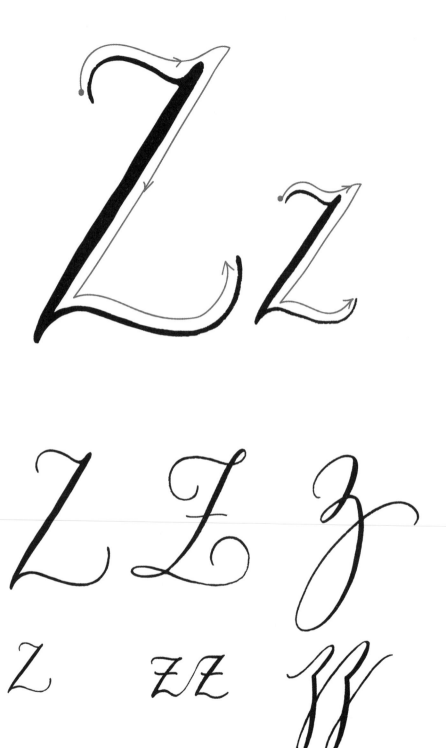

$\mathcal{Z}$ $z$

First learn
the rules

THEN *BREAK* THEM

1 2 3

4 5 6

7 8 9 0

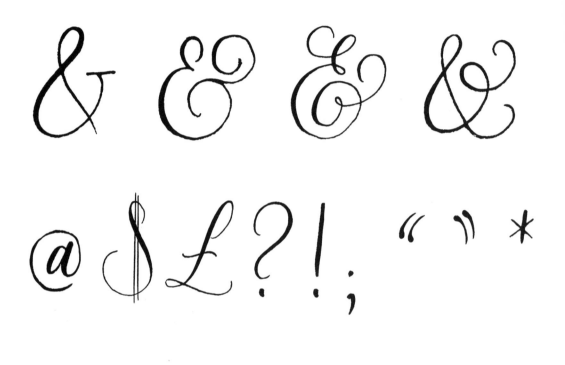

Aa Bb Cc Dd Ee

Ff Gg Hh Ii Jj Kk

Ll Mm Nn Oo Pp

Qq Rr Ss Tt Uu

Vv Ww Xx Yy Zz

*tip*

From your letter practice, see which versions you preferred writing and from this develop your own alphabet. This will be the basis of your style. Perhaps you preferred very slanted, angular, very curly or super-wide letters. Remember, it's all about what works for you!

PART THREE

*words*

MAKING WORDS
+
JOINING LETTERS

# MAKING WORDS
# + JOINING LETTERS

Ok, so you've practiced all the letters now and you're itching to put beautiful words together (if you haven't already had a quick scribble of your name . . . !). The reason why you've been repeating letters and shapes so much is to memorize these new formations. Your hands are so used to writing in a specific way we are almost retraining them to learn new shapes and make new muscle memories. This part takes a while, and you might even find that you need to go back and practice some more after you've dabbled with words. You know what they say about running and walking . . .

*tip*

You need a little consistency with your letters to create your own style. Does your pen always go a certain way when you write a particular letter? Embrace it, and add that quirk into your whole alphabet — consistency in your letterforms allows you to play around with shapes and angles and the overall look of your writing.

If you're trying to perfect calligraphy there are a few rules you need to be mindful of. Try to make them a habit; once you've got the hang of them you're then free to start experimenting with your own style. After all, modern calligraphy is about embracing your unique way of writing and playing with fun flourishes. So take the following points into consideration:

**1.** Be sure to form each letter properly, just as you did in your practice sheets. The connectors and tails between letters are so important to your overall look, so don't let their form slide and make sure they're always evenly spaced.

*Connectors*

**2.** Remember the correct proportions for your upper- and lowercase letters, ascenders, descenders, and loops. Use your guidelines to keep the size in check.

*proportions*

**3.** Keep consistency in your strokes. You'll see in the sample below that the loops are all a similar width, and the thicker strokes are all parallel.

*consistency*

**4.** The angles of your letters are also important — if the slant is off it tends to look messy, so choose your angle and stay consistent. Generally, the more slanted you go the more formal it looks. Loose modern styles are often upright and wide.

*Angles*

I would recommend practicing your words for a good hour at a time. Each time you go back to practice you will remember more and you will be able to see how much you've improved!

**5.** If all that sounds confusing, try to write out the letters of a word separately and see how they're naturally going to connect. This will help you understand how you will need to link them together.

**7.** When you're confident with your writing, feel free to start putting your skills into practice in the projects in the next part of this book.

*dovetail*
*dovetail*

*tip*

**6.** Use the next few pages to start practicing joining some words together. Don't be defeated if it doesn't look right at first: practice and check the points above.

Try to keep a steady rhythm to your words; it helps with consistency and keeps your arm loose and relaxed, too!

relax!

# FLOURISHING + DECORATING

Flourishes add a wow factor to your calligraphy; they're the cherry on your lettering cake.

You can add them anywhere to your letters — some come naturally (for instance, from a Y or a T) and others you can add in afterward, with a swift swoop. If I'm working on a finished piece, such as a greetings card or something to frame, I will sketch out the whole design in pencil and see where I could fit in a flourish. I'm generally looking for any imbalances or negative space on the page.

At first if the design is quite bottom heavy, try adding in some elegant swirls at the top to create an overall aesthetically pleasing balance.

Flourishing can be as simple as adding in extra curves to the ends or beginnings of letters or making large, dramatic sweeping strokes. Perhaps you just want to extend the cross stroke of the T, or make a super-big loop on your lower Y. You can add extra lines, fun splatters, ink dots, little illustrations and graphic elements to your letters — whatever you fancy!

Remember to keep your pen super light on the paper when adding flourishes; the nib only needs to kiss the paper gently and your arm needs to be relaxed and free. Flourishing comes from the larger movements of the arm, not the wrist, so keep your arm locked and steady. You can also apply some pressure to the pen while flourishing to add depth, but this means you will need to go slower — at the pace of your calligraphy writing.

Overleaf are some flourishing styles to practice with, so get flowing!

Have a
wonderful
day

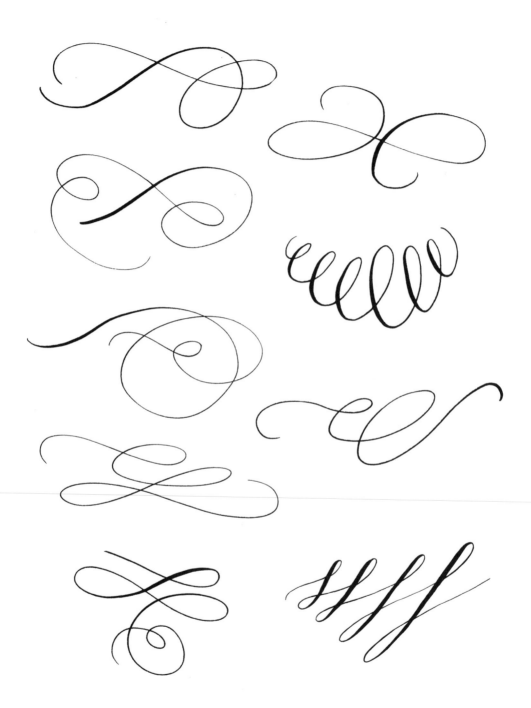

*tip*

Remember to keep your practice nice and slow. Speeding up can ruin your flourishes and letterforms!

# CELEBRATE!
## INSPIRATION FOR
## OCCASIONS

Trace, copy, practice, and post! Try these inspiring
ideas on your cards and tags or on your beautiful
handwritten letters. You can also add flourishes and
embellish your stationery as you wish. Enjoy!

*Bon Anniversaire*

*HAPPY Birthday!*

H | P   H | P

*hooray*

*make a*
*Wish*

*Let's party*

*Cocktails & Cake*

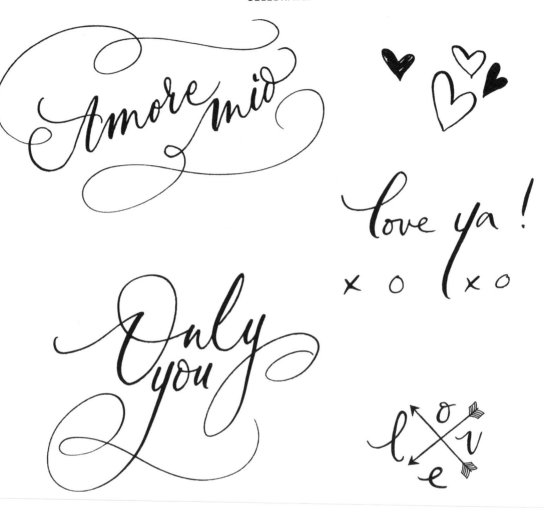

Amore mio

love ya !

x o   x o

Only you

hello handsome

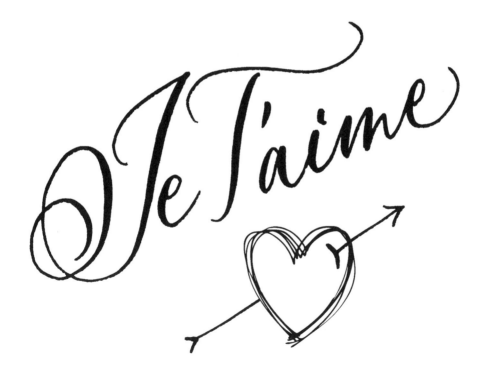

*my heart is yours*

*Je T'aime*

*forever + ever*

♡

*Love is all around*

*I do!*

*Tying the knot*

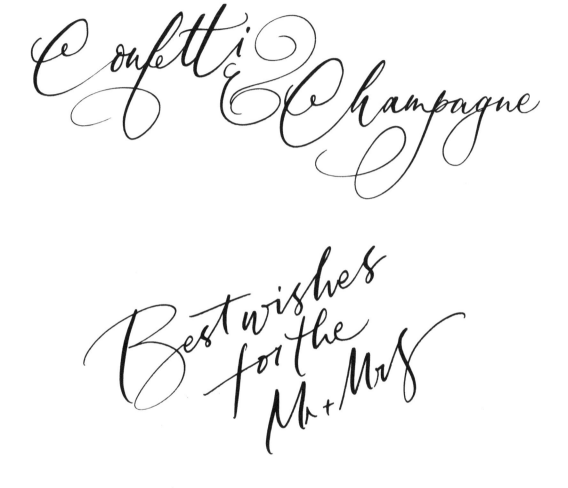

Confetti & Champagne

Best wishes for the Mr + Mrs

perfect pair

A wonderful life

New home

pitter patter

hats off to you

crazy grateful

Welcome home

Here's to
life's adventures

Ghouls and Goblins

The Wicked Witch

A little black magic

Trick or treat

Boo!

Happy Halloween

Mulled wine & apple pies

Merry & bright

Hohoho

*sleighbells ring . . .*

*Christmas wishes*

*santa's helper*

*Cherrynose!*

PART FOUR

*projects*

STATIONERY,
GIFTS,
PARTYWARE,
TABLEWARE
+
MORE

# STATIONERY, GIFTS, PARTYWARE, TABLEWARE + MORE

After your hard work practicing and learning the basics of modern calligraphy you can enjoy getting started on some creative projects that all call for your new handwritten skills. There is huge opportunity to bring an element of modern calligraphy into your everyday life, in the form of handwritten notes, gifting, and embellishments, and over the next few pages you will find some ideas and inspirational projects to get you started. You'll soon see the options are *endless*, and with such a huge trend for personalization you will be flooded with ideas for how you put your new hobby to good use. This is the beginning of your handwritten journey — keep up the good work, discover your style, and enjoy the challenges and pleasure it brings you!

# GIFT TAGS

Use these templates to cut any card to shape and add your desired message. Personalize these gift tags with polka-dot paints, ink blots, or a strip of patterned washi tape to add color. Punch a hole at the top and thread the card with string, glittered twine, or ribbon. These tags are great for gifts, wedding favors, save the dates, party bags, or just to brighten up your food cupboards. You could even add a candy cane for a Christmas stocking filler!

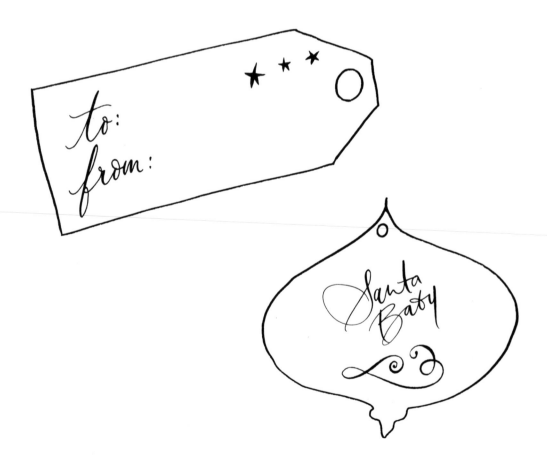

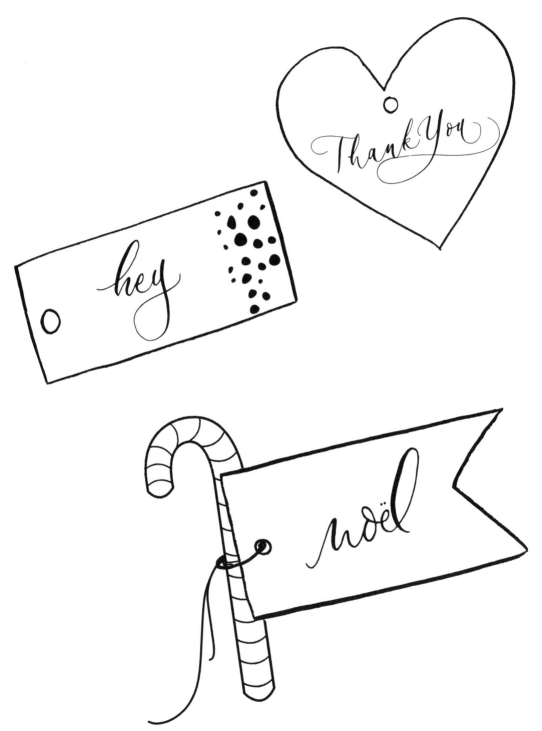

# WREATHS

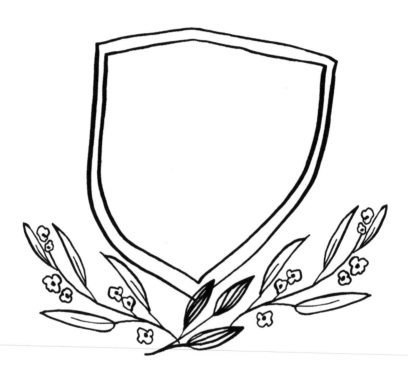

Decorative wreaths are so popular — and for good reason! Use these designs on your stationery, cards, tags, logo, or envelopes or to finish calligraphy for framing. They're a simple but effective way to embellish initials and make lovely DIY monograms for a wedding or birth. Try a word in the wreath design, or trace these onto layout paper.

# WRITING ON MUGS + PLATES

You can practice your new writing skills on ceramic mugs and plates with Sharpies or bakeproof markers in a few easy steps. These make very cool personalized gifts, and now with metallic and pastel colors of ceramic pens available, too, there are so many choices. You can create your own lasting message in just four simple steps!

1. Choose a lovely porcelain piece and make sure your plate / mug / tray / bowl / vase is clean and oil free.

2. Sketch out your desired message on paper in pencil so you can copy this easily onto the item. You might need to do a few copies to get it perfect. If you want to keep it simple, initials are a great start, and you can refer back to the alphabet pages in this book for a few ideas. For a special touch you could add illustrations or flourishes here if you wish. To get the "calligraphy" look with a marker pen you will need to imitate where the thicker lines appear in calligraphy, which is on the downstrokes. So add in the outer lines manually then color them in, in the middle.

3. Bake the items in the oven for 30 minutes at 350°F (180°C).

4. Remove from the oven and allow the pieces to cool completely before getting them wet.

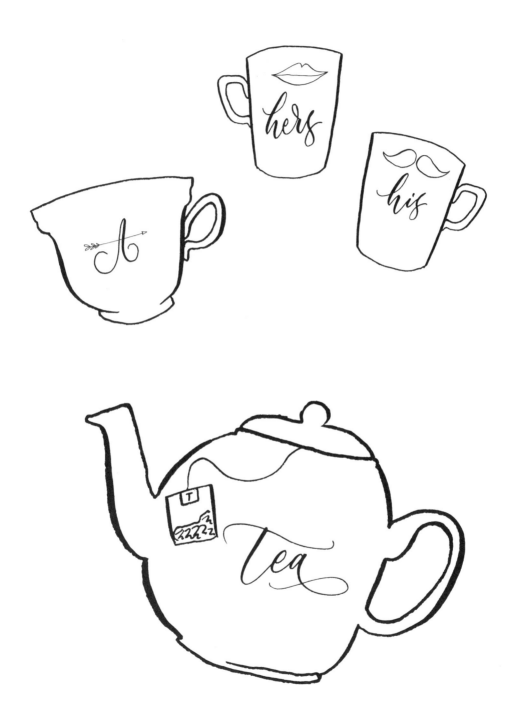

# ENVELOPES

There are so many ways to make envelopes fun and interesting. Imagine how someone would feel when a beautifully decorated envelope drops through a letterbox with your calligraphy skills on it; it's such a treat for the receiver and a welcome surprise among bills and statements! It can be a lengthy process to create an envelope design, but the results are worth it; the envelope is often the first impression you can make for a party or wedding. It's a great project to work toward.

Here is how to set an envelope in a formal way, and a few things to take into consideration if you're posting out a lot of invitations.

## THINGS TO CONSIDER:

• Time. Think about how long it takes you to write one envelope perfectly, then multiply that for the number of envelopes you want to send out to get the total amount of time the project will take. Add a little extra for mistakes and breaks. It can often take days to write 100 envelopes in calligraphy, so plan ahead.

• If you're planning to write envelopes for an event or to send out a lot of thank-you cards it's worth buying 15 percent extra number of envelopes to allow for any ink mishaps or spelling mistakes.

• Print all your guests' names and addresses how you want them to be written out. It makes life much easier if you can see the text as a whole before you start.

• Have your alphabet on hand to refer to for consistency and style guides.

• Remember that good-quality paper works best with calligraphy inks and nibs, so get a sample of the envelope and write on it with your ink to check it doesn't bleed before committing to a large number of them.

• Set your envelopes to dry propped up in a cooling rack or clear a large space on a flat surface to lay them out.

Check how many lines you will need to write the whole name and address

Have a template or pencil line to keep your individual lines justified to the center

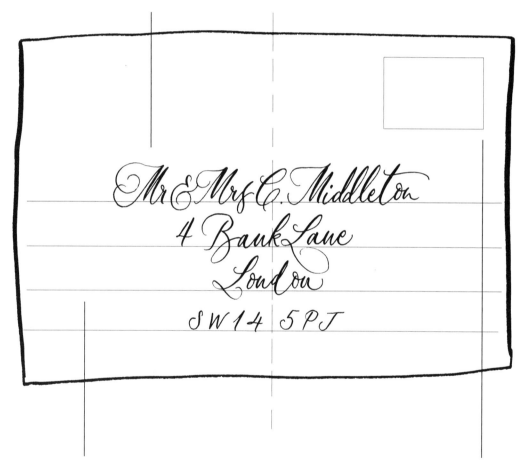

Keep an equal distance between the lines

I try to keep the letters and numbers the same height for a uniform look

Make sure you leave enough room for the stamp and a post office date stamp

If you're making one special envelope these are some great ideas to turn it into a piece of art!

**1.** Draw a tag on the envelope and write the address on the tag.

**2.** Add a scroll for the name.

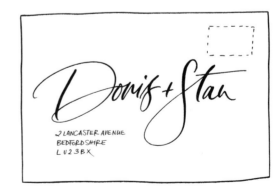

**3.** Write the name as a very large statement with the address small and in capitals, or use first names only.

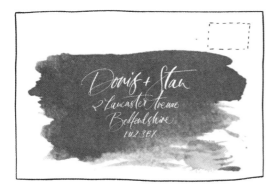

**4.** Paint the envelope in watercolor or use a dash of watercolor and write over the top.

**5.** Use flourishes.

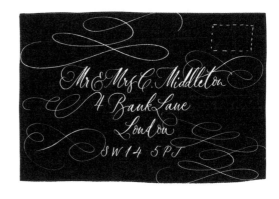

**6.** Use polka dots / stripes.

# QUOTE IN A FRAME

Your most-loved lyric, poem, reading, or even your favorite word or place name will look so beautiful handwritten and then framed. These are the perfect way to celebrate a special occasion and work well as wedding gifts, birthday presents, to mark the birth of a new baby, or just as a personal message for your love.

Copy the options overleaf for inspiration, then follow the steps to create a meaningful gift or a lovely piece of homemade art for your wall! First sketch out your ideas on layout paper, then analyze the design to see where you could add flourishes or any other interesting graphic elements, such as illustrations, lines, or dots. Practice a few times on layout paper and make sure you have a sheet of good-quality paper for the final piece. You might need to write out the wording a few times but it will be so worth it when the piece is finished. Use the templates opposite for inspiration and guidance. Choose 8½ x 11-inch or 5 x 8-inch paper — these sizes usually work best and are easy to frame and get in the right paper stock.

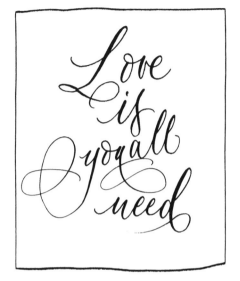

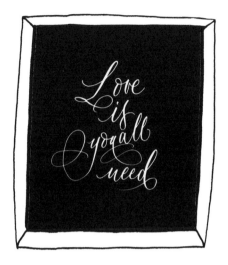

# CHALKBOARD LETTERING

Chalkboards have so many uses, be it as welcome signage, to display table numbers, drinks lists, or just for your kitchen shopping list. You can buy premade chalkboards very easily online, or you can use any piece of wood or empty frame and then paint it with blackboard paint. The paint is readily available at hardware and art shops and one coat is usually all that's needed.

You can write on the chalkboard using good old-fashioned chalk sticks — which are cheapest and give the popular vintage effect. It's also the easiest to rub off! Alternatively, you can use one of the many white chalk markers that are on the market. My favorites are the Posca white pens, which come in lots of nib sizes, but these are permanent so when you are finished with the board you might need to paint it again to get it blank. If you want your writing to wash off you can use a white glass pen, which you can wipe clean with a wet cloth. You can also use these pens on mirrored glass — this has a beautiful effect but is harder to do because you can't draw your outlines in pencil first!

## HOW TO DO CHALKBOARD LETTERING:

Make sure your blackboard is completely smooth and clean, as any dust or dirt will ruin the pens quite quickly.

Sketch out your design on paper first; this will make it easier to copy the lettering onto the board. I usually use a white pencil to mark out the whole piece and then draw over this in chalk pen.

Using chalk or pen won't give the effect of different-pressured strokes as our nibs do, so we're going to imitate calligraphy here. Any part of the letter that would be a downstroke should be made twice as thick, then color in the gap in white. Apply this technique to the whole piece then add any flourishes as you wish.

Composition is key here, so be critical with your finished piece. Does it look pleasing to the eye? Is it balanced? Could some words be exaggerated for more oomph? Would a frame work well if you don't already have one on the wood?

*tip*

If you want the vintage look, rub a bit of chalk over the board first to give it a worn appearance then wipe it over with a rag to remove any excess. It doesn't need to be even.

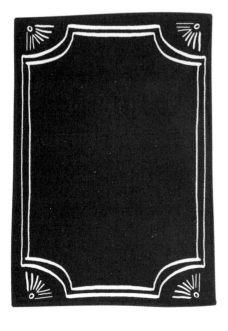

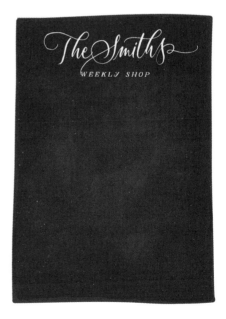

# PARTYWARE

You can create menus, banners, balloons, straw flags, save the dates, and garlands, as well as extra-special inexpensive paperware for your birthday bash, anniversary party, baby shower, christening, or wedding using calligraphy. Use the templates and ideas below for inspiration, and get crafty!

Let's be honest — with your new skills you can write on anything for a party; all you need are some markers, some creativity, and a little time! For inspiration, see overleaf . . .

## STICKERS
Buy sheets of very cheap blank stickers and add your calligraphy to them. You can use them to seal your envelopes, add to party bags, and more.

## PAPER PARTY BAGS
Write your guests' names in marker onto brown or white paper bags for an instantly special party bag.

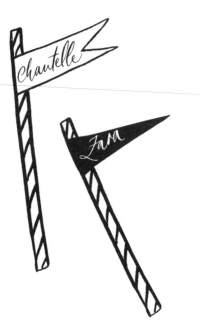

## FLAGS
Straw flags are super popular, especially if you want to personalize drinks or put a theme in place.

Use any colored card, but make sure it's not too thick as it won't bend as well. Cut the card to shape from the template ideas opposite and write out the guest's name or message in calligraphy on one half. When dry, add double-sided tape to one half and fold it around the cardboard straws. Voila! Very cute cocktails.

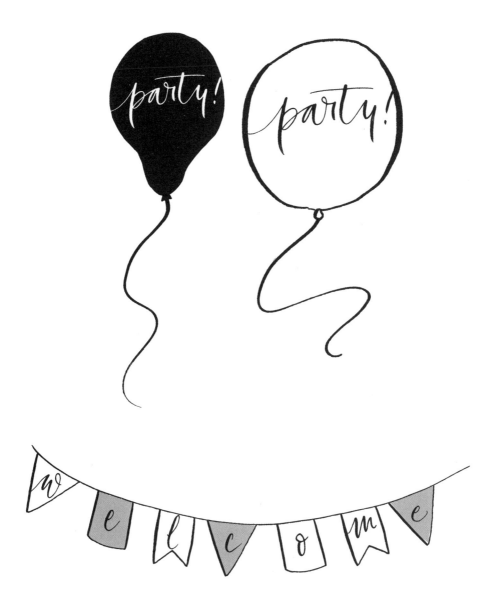

## BANNERS AND GARLANDS

Cut shapes out of card and design one letter per piece to spell out a word, name, or message. These banners can be used for so many occasions in a range of colors. Hole-punch the tops and string together with twine. Be creative with colors and shapes. Add tassels as you wish!

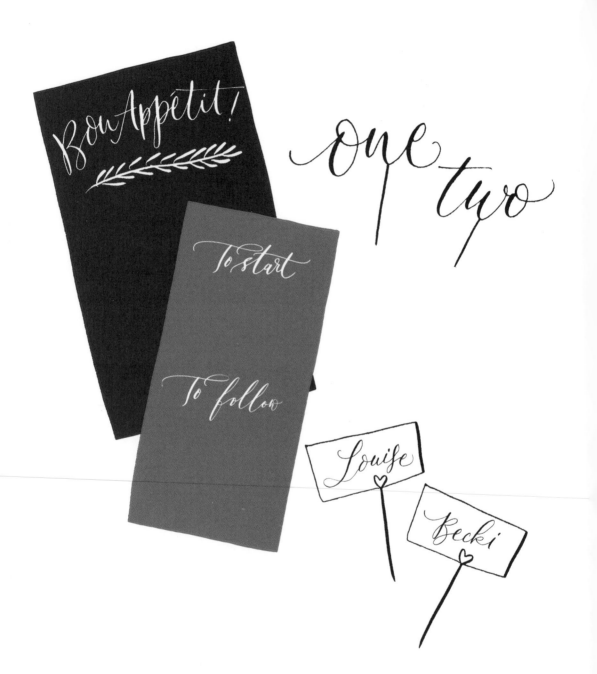

# DINNER PARTY

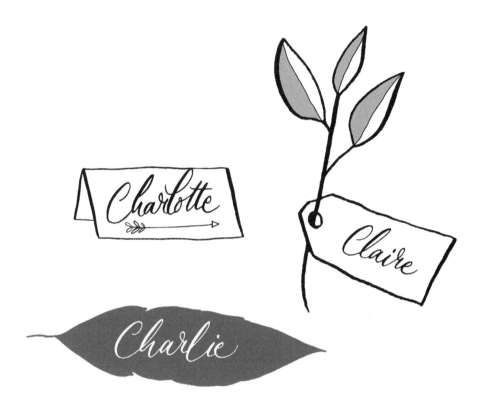

There are so many ways in which you can use calligraphy to make a dinner party a visual treat as well as an appetizing one. If you have a theme for the event, run it with colors, and experiment with different inks, papers, and objects. You can mix printing with calligraphy — for instance, print a menu but add the guests' names at the top in calligraphy to double up as place settings. I also love the idea of using slate or brown paper and writing guests' names large to make rustic place mats and place cards in one.

Here you will find some template ideas for how to create menu cards, table numbers, place settings, and many more table dressing items using stationery — all of which can be decorated using calligraphy.

# <u>FAQ</u>s

After teaching modern calligraphy workshops (and of course learning myself) I can safely say that I know what most beginners struggle with when they are first starting out with calligraphy. I hope you will find the answers to the most common issues below, but if not, feel free to drop me an email!

Q  **Can anyone learn calligraphy?**

A  *Yes, absolutely anyone can learn how to do it and can have fun with it, but to really master calligraphy and achieve a professional look does take a lot of practice and patience. If you want to keep it simple, have as your main goal just to bring a handwritten element into your everyday life, in your own style.*

Q  **How do I choose supplies?**

A  *Have a look at my list of supplies on page 18-21. There's a lot of choice out there, so feel free to experiment with other brands and items — these are just my favorites to give you a head start!*

Q  **How often should I practice?**

A  *If you love what this book has offered, keep up the good work by practicing a few hours every week. You'll see an improvement and regular practice will build up your muscle memory.*

Q **Can left-handers do calligraphy?**

A *Yes, absolutely! If you're left-handed you'll fall into one of two types of writers: "under" (you hold the pen out in front of you) or "over" (you curl your wrist over the page). For underwriters, you can simply mimic how righties work — the nib is symmetrical. For overwriters you'll need to work in the opposite way, because you'll be putting pressure onto the nib as you pull the pen upward. For lefties it's best to stick with straight penholders as an oblique holder is set at the correct angles to work with a right hand. Don't be put off; you can adapt to suit your angles and still get great results.*

Q **My hand is hurting! Does calligraphy always hurt?**

A *No, calligraphy should be a really enjoyable activity! If your hand is hurting you're probably holding the pen really tightly. Check with the guides on page 24 to make sure you've got the pen at the right angle and keep your fingers, arms, and shoulders nice and loose to get the best results.*

Q **Why does my pen feel so scratchy?**

A *If your nib is collecting fibers, scratching down the page, or even making holes in the paper you're putting way too much pressure on it. Lightening your hand and technique is one of the trickiest things to learn. If this sounds like you, shake out your hand and wiggle your fingers like jazz hands, then rotate your wrist a few times to loosen up your muscles. Let the pen rest lightly in your hand — don't tighten your grip at all. The ink flows as soon as you touch the nib to the paper, so you really don't need to press down very hard at all! Try squiggling some light strokes and you'll see what I mean!*

Q **Why do my upstrokes feel spidery and wobbly?**

A *To avoid a wobble on your upstrokes you need to work out the right speed at which to write. I've mentioned lots of times about keeping your pace quite slow, but if you go too slow you might find your hand has time to wobble. It's about working out the right speed for you. Your speed will also affect the width of your strokes and the smoothness of your curves. See? I told you it was about practice!*

Q **Why can't I get the thick lines from my pen?**

A *Don't be scared to put a little pressure onto your nib. Check you've got enough ink in your nib and then experiment with the different thicknesses of lines you can get from the nib. Try to match the strokes on page 30.*

Q **There are bits of paper stuck in my nib and I can't get them out!**

A *Sometimes pressing too hard into the paper can cause small fibers to get stuck, then they get dragged around and ruin your calligraphy. To get these pesky pieces out, make sure you've emptied the nib of ink and put pressure on it while dragging it slowly toward you — this will open up the tines and release any caught fibers.*

Q **Can I use the same nib for different-colored inks?**

A *However much you seem to wash black ink from your pen, there can often be a little bit lurking in your penholder, so if you're planning on using white, colored, metallic, or pale inks I would recommend buying a separate penholder and nib. I personally have a different one for every color!*

Q **I can't seem to keep my writing on a slant angle — any tips?**

A *Use the free downloadable guides available on lamplighterlondon.com or those in this book, which have diagonal lines on them to help direct the angle of your writing. If it helps, turn the page on the table — you can position the paper any way that works best for you, and it can make a huge difference to the angle of your writing.*

Q **My nib keeps running out of ink!**

A *Your reservoir should be full past the hole in the middle of the nib, so make sure you are dipping the pen past this point. A full nib should last a few words, but at first you'll need to experiment with how long you can make it last, and you'll definitely get to know the "feeling" of when the ink is running low. Make sure the nib is dipped far enough into the inkpot, as per the guides on page 25.*

Q **Why does my nib seem to be letting out lots of ink onto the page?**

A *When the tines are opened, the ink is free to flow onto the paper, so you will need to find the balance between how much pressure you put on the pen and how fast you move it to make sure the ink is evenly distributed.*

Q **The ink is bleeding out into the paper. How can I stop it?**

A *Unfortunately calligraphy doesn't work on all types of paper — printer paper, textured thinner papers, and often some cheaper envelopes aren't ideal because their loose weave allows the ink to bleed out, creating spidery lines and making text illegible. This is where quality products really make a huge difference. All the papers I've listed in the supplies section are bleedproof.*

Q **How can I create my own calligraphy style?**

A *Work on creating your own alphabet and practice it a lot. Try to put your unique touches onto letters — however much you imitate someone's style it will always be different because no two hands are the same! My advice would be to look at the work of other calligraphers for general inspiration, but don't focus too much on copying their style and stop looking at the Internet for ideas; the aim here is to develop something you feel comfortable with and that is personal to you. Look to the past for inspiration, too — old films and posters and packaging offer a wealth of creative type.*

**With lots of practice I promise you will develop a unique style that you love.**

## ACKNOWLEDGMENTS

As a visually led creative I normally spend my days illustrating decorative lettering and calligraphy, so writing *Nib + Ink* has been an exciting challenge and an enjoyable part of business for the past year. As my first foray into the intricate publishing world, it wouldn't have been possible without the help and support of many wonderful people that I'm very lucky to have in my life.

My editor, Elen Jones, and the team at Ebury, Virgin Books and Penguin Random House have been brilliant and a joy to work with. I was honored to receive the first email from Elen asking me to consider writing and illustrating an inspirational modern calligraphy book. We have worked closely on the project, sharing the same vision and excitement in reviving beautiful handwritten notes. The fantastic graphic designers Ben Gardiner and Steve Stacey have brought my ideas to life, creating an aesthetically pleasing visual guide from my writing and illustrations.

I am so grateful to my dear family and special friends who have encouraged and reassured me, given advice and discussed the nitty gritty; mostly over wine of course. And to Michael, who has supported and motivated me every day, I am wholeheartedly thankful.